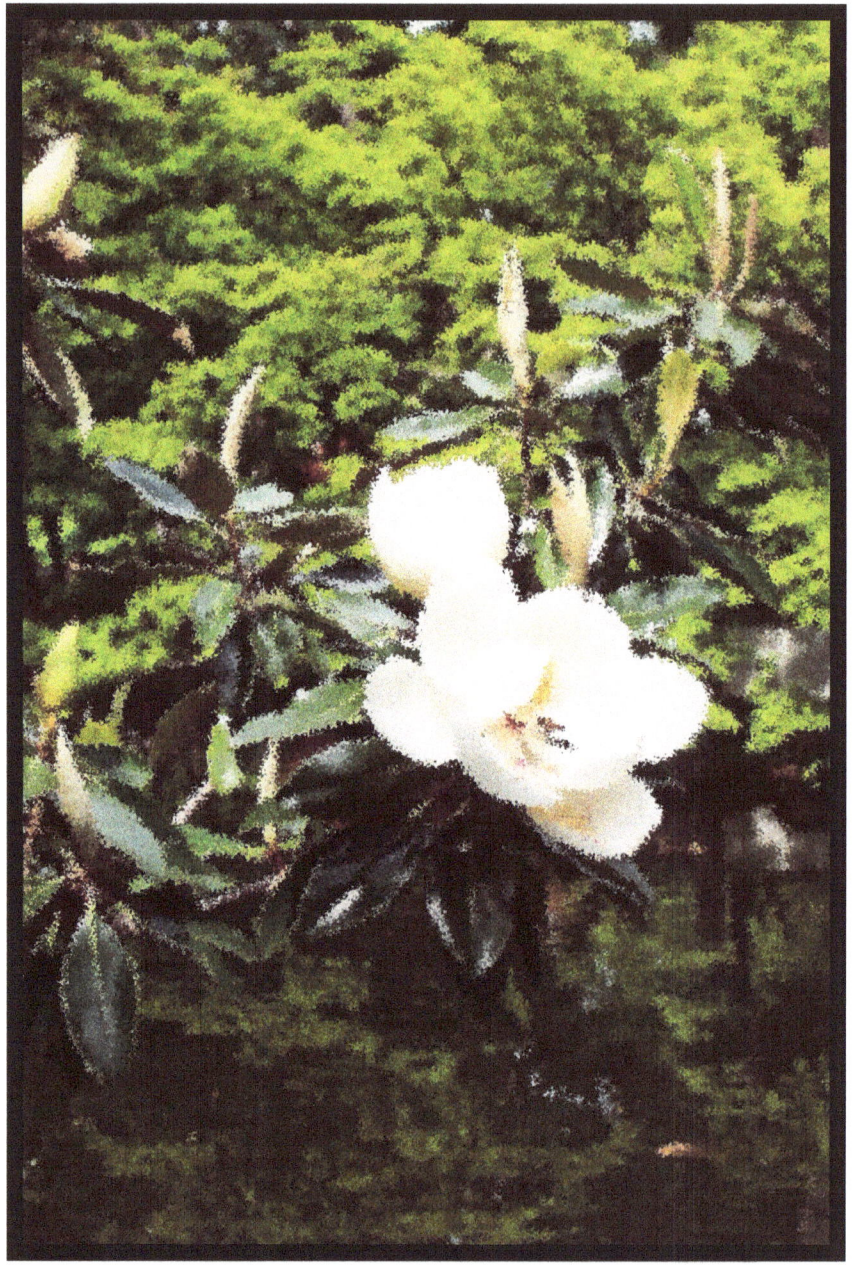

Japanese Garden - Magnolia
Digitally Altered Photo by Lisa Vollrath

I took this photo during an outing to the Japanese Garden in Fort Worth. I had just seen the film The Impressionists, and thought the photo looked very much like something one of them might choose to paint.

Artists in This Issue

Deirdre Abbotts is fiber artist who dabbles in whatever catches her interest. Art quilts and photography are two of her current passions.

Cyndali is a mixed media artist delving into all manners of recycled materials, including those left by nature. Her favorite use of these castoff items is as wearable art, usually in the form of one-of-a-kind jewelry pieces.

Debe Friedhoff has been working in altered art for two years. She lives in Missouri, and specializes in altered shoes.

Roberta Schmidt is a creative artist, living in Northern California. She loves using a camera, computer, printer, paper and glue to create mixed media art, as well as digital art.

Tara Ross creates frolicsome creatures in the studio adjacent to her home in Seattle, Washington.

Hanna Andersson, a.k.a. iHanna, is a journalist, mixed media artist and all around creative person. Hanna lives with her cat Smilla in Sweden.

Lisa Vollrath is a prolific mixed-media artist. Her work covers a multitude of techniques, from altered books to collage, from artist trading cards and decos to textile art and costume design. She has written dozens of books and how-to articles for arts and crafts publishers. Her current work can always been seen on her ever-growing web site, LisaVollrath.com.

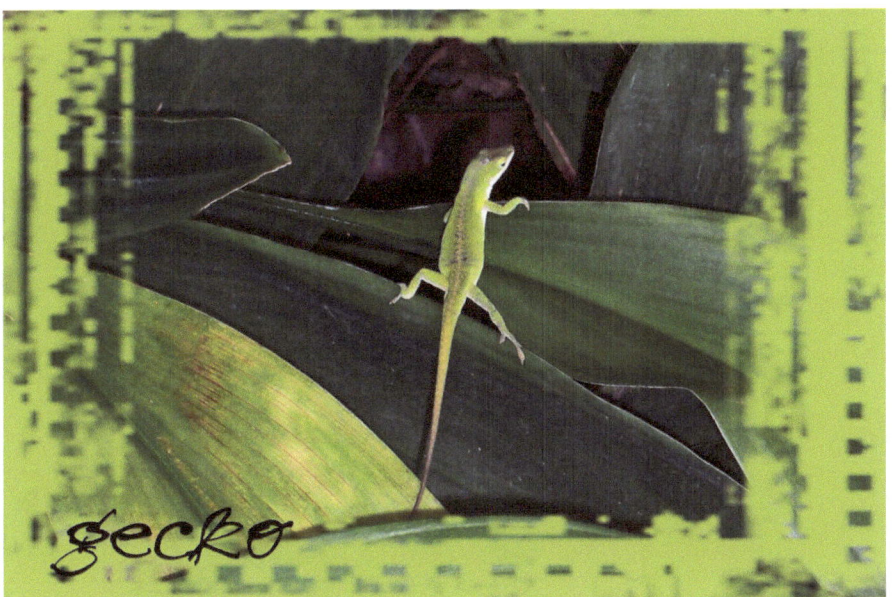
gecko

A Few Words From Lisa

For the past seven years, I've been renovating the interior of my first house. In January, I realized the inside projects are winding down to things that can be finished with a weekend here and a weekend there---and as soon as that realization settled in, I noticed that the exterior of the house was long overdue for some attention. Ah, the joy of home ownership---the to-do list never seems to end.

I've spent the past six months learning about landscaping, and looking at the outside of the house with fresh eyes. Every plant, rock and brick has been inspected and considered. I've learned about landscape techniques from a professional who specializes in creating garden plans that require no watering beyond what nature provides. I've been instructed to look at every front yard I drive past, and inspect it for possibilities. I've learned that innocent little arbor vitae bushes planted all over the neighborhood as gallon-sized shrubs will grow to trees that tower over the houses and completely cover the lawn. Mostly, I've learned to appreciate all things green. The are indeed mysteries that demand exploration.

This will probably be the last issue of Bad Influence for a long while. I've decided to take a break from producing books and zines in print, in favor of things that are digital. Perhaps I've been influenced by all the green in my life---I just don't feel good about all the trees I've been killing with printed products that can be delivered via alternate means. Enjoy this printed zine---I'm afraid it's one of a dying breed...

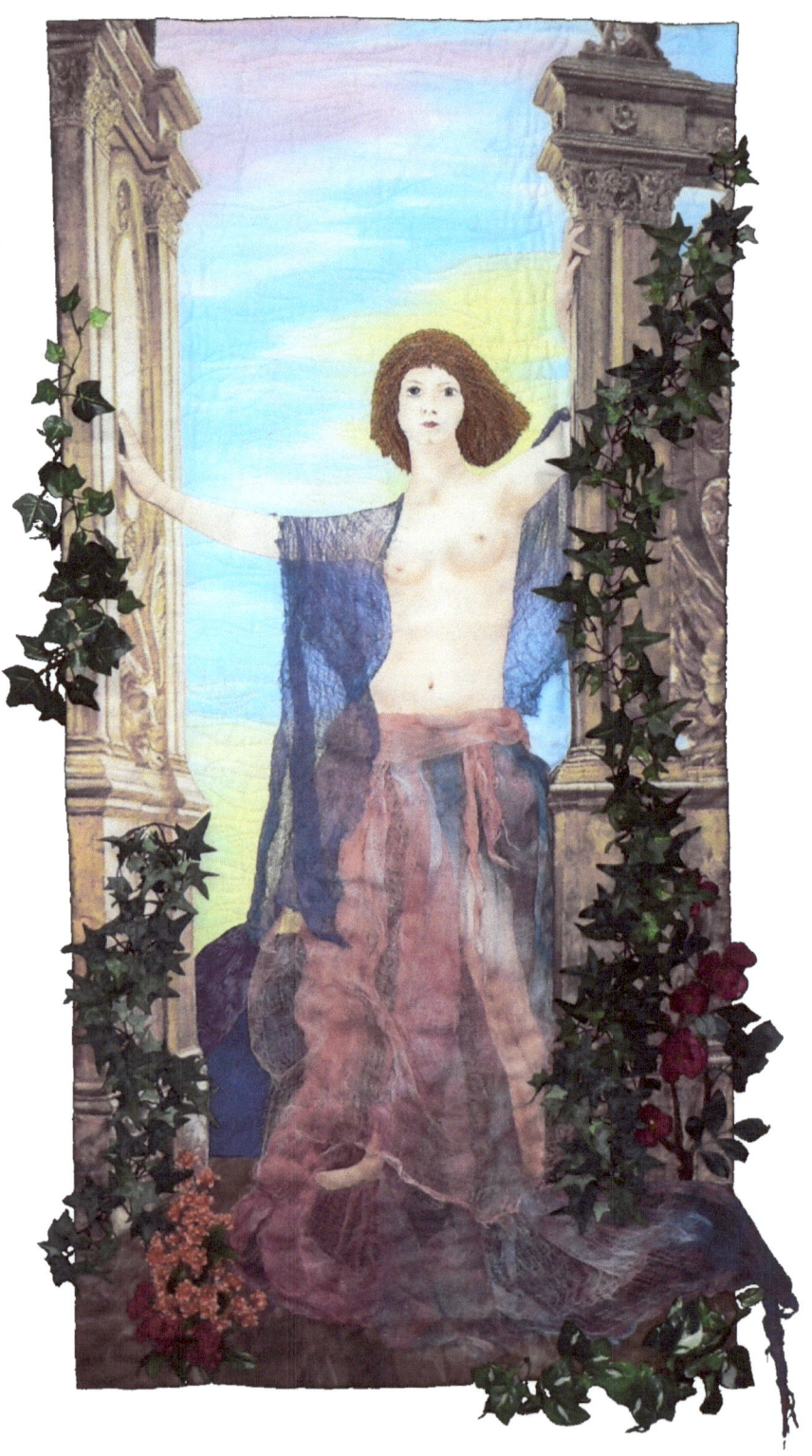

The Gates of Dawn
24 x 36 inch mixed media quilt.

Inspired by a painting from 1900 by Herbert Draper, my adaptation shows Dawn as she opens the gates to awaken the world, you can see a glimpse of her gardens as you enter the gates.

This quilt combines several of my favorite techniques. The face and body are hand-painted cotton. The columns are printed by me using my inkjet printer and treated fabric. Dawn's hair is made by sewing multiple colors of rayon thread on a water-soluble base, which once washed away leaves the hair entirely made of interlocked thread! These items are appliquéd onto a hand-painted background and further enhanced by hand-sewing silk flowers and ivy leaves after removing them from their wired forms. Additional accents are set off by the use of metallic threads and ultra-fine glitter.

This quilt includes a hand-painted figure and sky. The gates were printed in full color on an ink-jet printer, from Herbert Draper's painting (c1900). The hair was hand-guided embroidery with multiple layers for depth, and the clothing was constructed from hand-dyed gauze. The mountains, floor, binding and backing are commercial fabrics. The botanicals are hand applied silk flowers and leaves and are embellished with beads and colored threads. The body is backed with ultra-suede for support.

Art By
Deirdre Abbotts

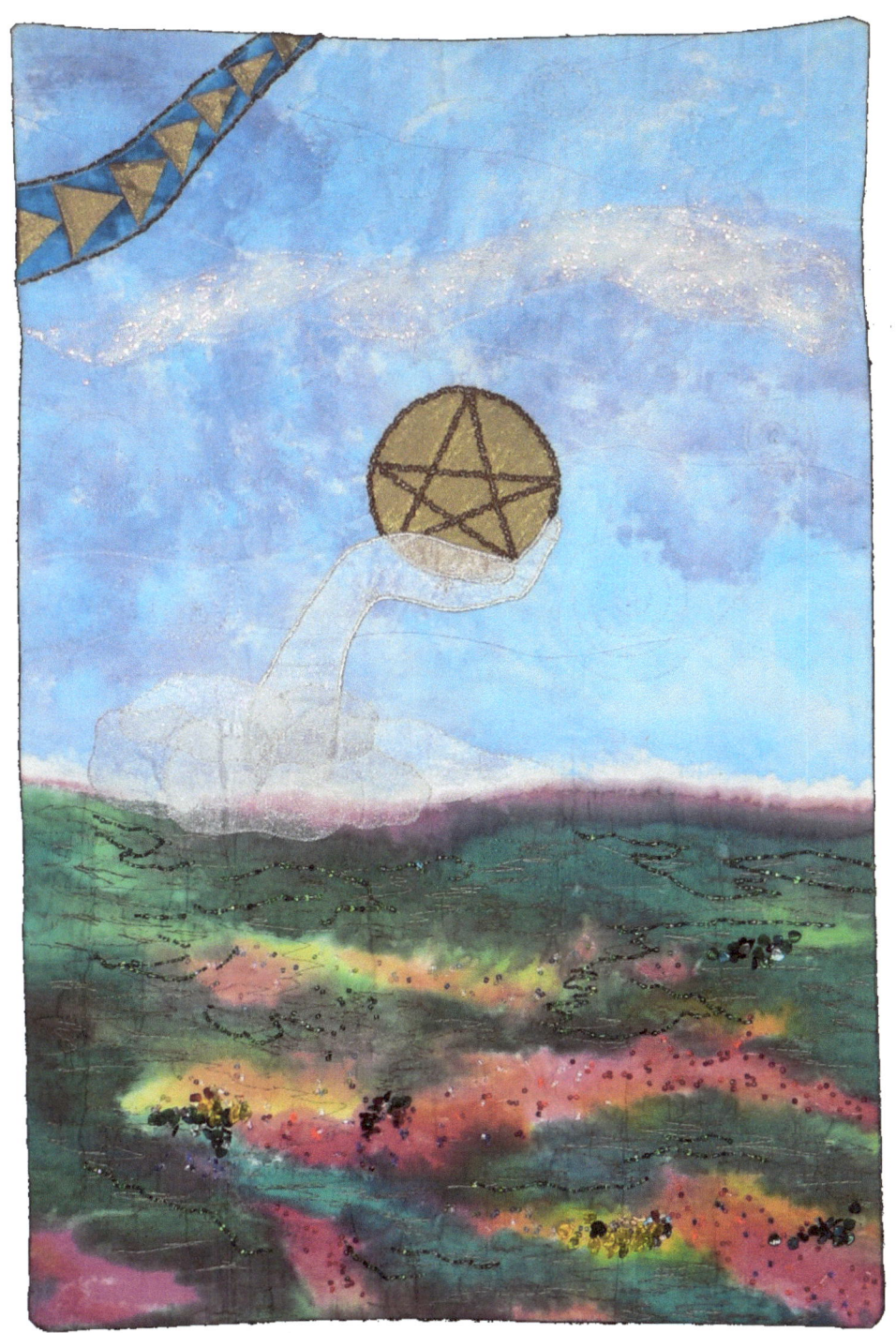

Ace of Pentacles - The Golden Goose
24 x 36 inch mixed media tarot card.

This quilt was one card of the Tarot Art Quilt Project. It was hand-painted, machine appliqued and quilted. The beading was done both by hand and machine. Based on a traditional Ryder Waite tarot deck, this image used sheer organza for the transparent hand. Angelina fibers (loose and not fused/flattened) is captured under tulle to form the cloud. The traditional Flying Geese pattern in the upper left corner was quilted with gold material, to signify the chase for the "Golden Goose". This image is set in a lush garden with mysteries surrounding all who enter.

Art By Cyndali

Dirt Dobbers
Altered Board Book

child's board book, bronze caulk, chicken wire, moss, acrylic paints, sand, dirt dobbers nests

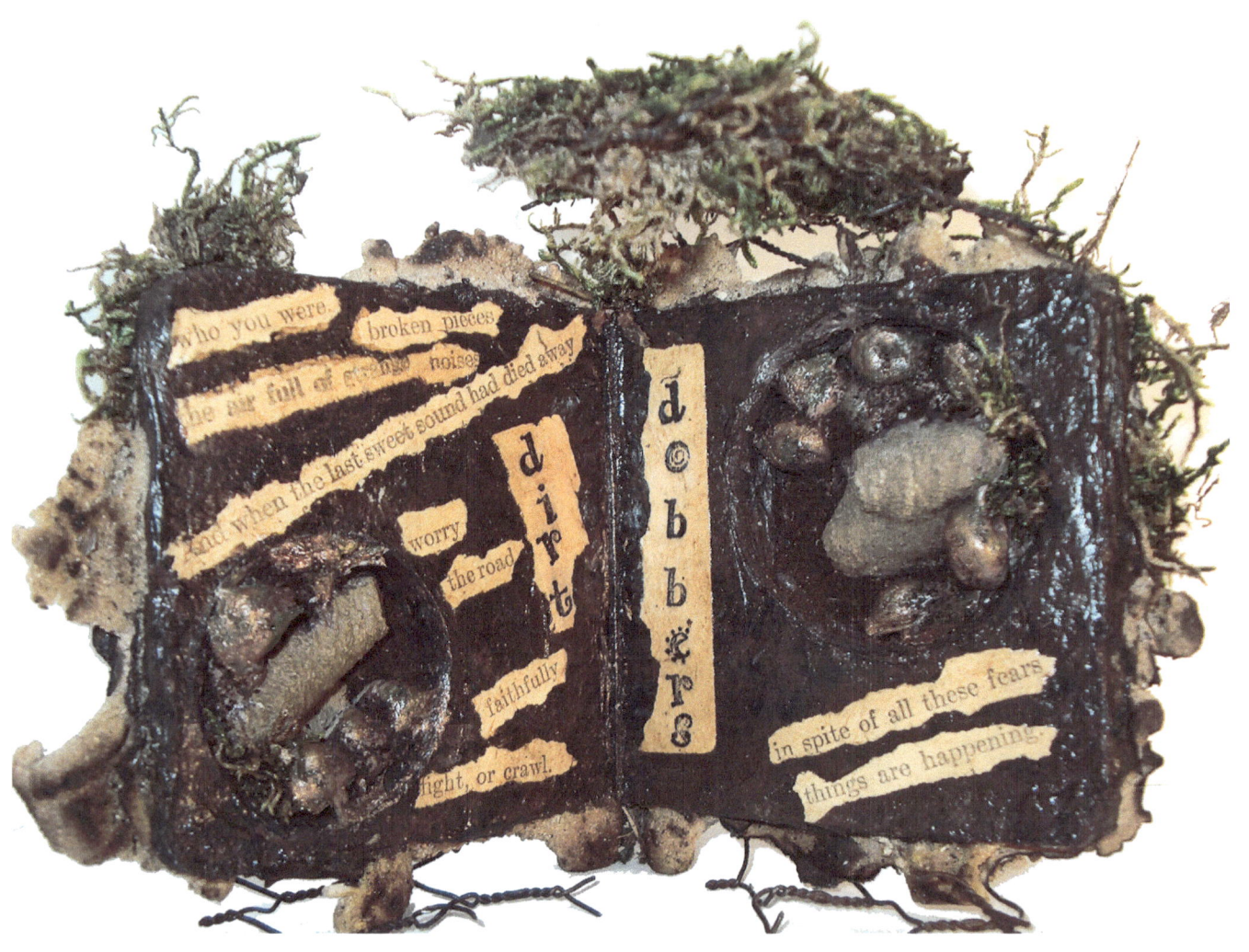

When I go into my garden with a spade, and dig a bed, I feel such an exhilaration and health, that I discover that I have been defrauding myself all this time in letting others do for me what I should have done with my own hands.

--- Ralph Waldo Emerson, 1849

In the Garden of Tomorrow
Altered Book Pages

old book, paper napkins, old sheet music, art print, metallic paints, lace, sequins

"I made this for a friend, and liked it so much I almost could not let it go."

Art By Debe Friedhoff

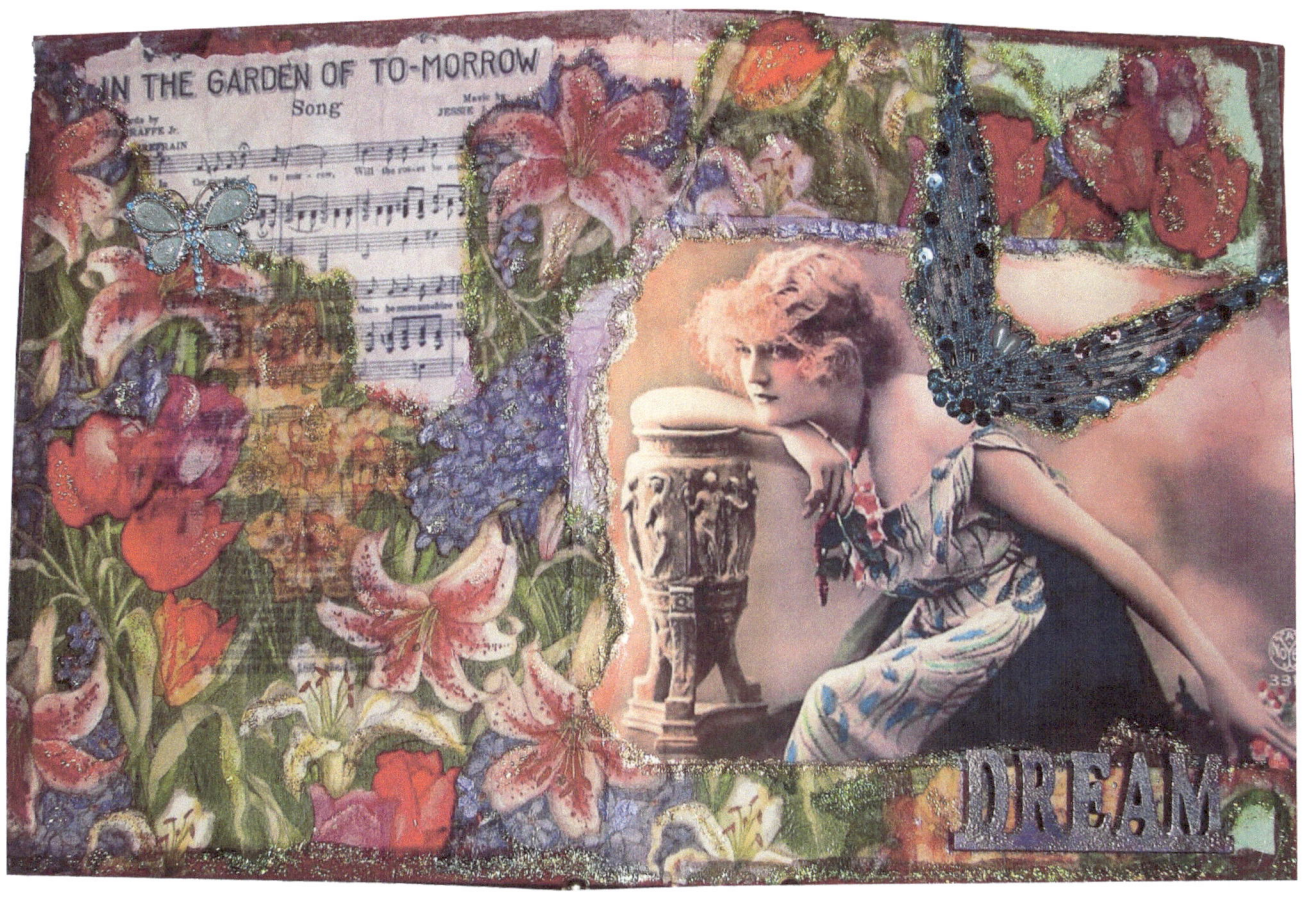

There is a garden in her face,
Where roses and white lilies show;
A heavenly paradise is that place,
Wherein all pleasant fruits do grow.
There cherries hang that none may buy,
Till cherry ripe themselves do cry.
---Unknown, 1606

Garden Girl: The Art of Corinne Stubson

I first met Corinne Stubson through the altered books group on Yahoo, sometime in 2002. Over the years, we've done a steady stream of projects together, and have come to know each other as women and as artists. When I decided to do an issue about the garden, Corinne was the obvious artist to profile---I've been begging her to come to Texas and work her magic on my half acre ever since she first shared photos of her own lovely garden.

OK, girl---tell the world a little bit about yourself!

My name is Corinne Stubson. I've lived in beautiful SW Oregon in the Rogue River Valley for 30 years, but am a 'born and bred' California girl. I grew up in a family of two parents, and four children (with me being the youngest, and only girl.) I've been married for nearly 41 years to a professional violinist/educator. We have two grown sons, three grandchildren, a cat and several fish in our garden pond! I am also daughter to my wonderful almost 95 year old mom, who lives nearby.

What do you do for a living?

I create mixed media artwork, and teach art classes in a variety of forms - altered books, beeswax collage, coptic book binding, and more. I am a retired nurse, and with my husband retired from his 'day job' as a public school music educator, we both have time and a bit of retirement pension to devote to our respective art lives.

How did you find your way from nursing to art?

My desire to be creative has really been with me my whole life, from a very early age learning to knit, sew and crochet, to my present artist life. I created a variety of needlework items, all of my stained glass work, and developed our garden retreat, while working full time as a nurse and rearing our family. What allowed me to blossom (pun intended) in my 'new' art life was the simple fact of quitting my job to care for my then-dying father, in 1995. My mother needed my help, and my call was to be there for both of my parents, as they had always been 'there' for me. Once my dad passed away, I made the decision (with my family's blessing) to not return to work nursing. Gradually I spent more time with the creative side of my psyche, and here I am.

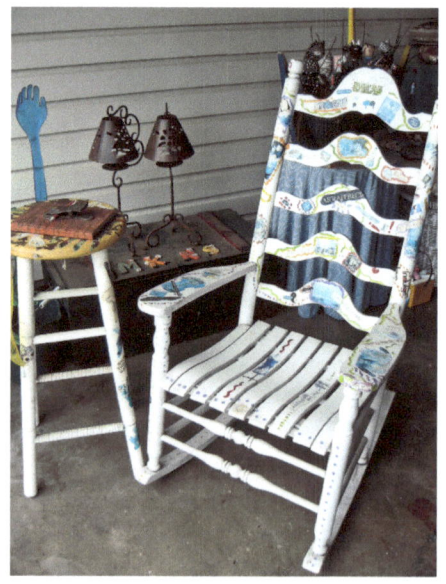

"This is the antique rocker given to us as a gift when our older son was born. I painted it about 6 years ago as a garden seat - collaged with images and sayings having to do with gardens, music, and the spirit - with some handpainted elements added. The 'Handstand' next to it is also my work- and is the resting place for the garden guest book."

One added blessing in this transition has been still having the company of my mother, my first art 'teacher', and from whom I learned all about gardening.

Have you had any sort of art training?

I've not had any formal art 'school' training, but have been working with my hands in some art form or other most of my life. As an adult, I have taken classes in stained glass art, book binding, collage, and a variety of mixed media techniques. I read a lot, and have taught myself many art techniques from book instructions and ideas, including beeswax collage and some book binding. I also belong to a number of online art groups, and have learned a great deal from the sharing of techniques by other artists. Though I came to creating altered books on my own and independently in 2001, I have since developed a great deal of knowledge and experimented with ideas , with big thanks to the sharing members of the Altered Books Group on Yahoo and the members of the International Society of Altered Book Artists (ISABA).

How would you describe the types of art you do?

I consider my art to be mixed media, given that I work with a variety of objects in my art, and in a variety of art disciplines. I consider myself primarily a 'book artist' - creating art using existing books, more precisely using books to make art sculptures and statements by cutting then up, painting, embellishing and otherwise changing them into new art objects. I also thoroughly enjoy creating collages using beeswax as the 'adhesive' medium. I love making my own journals, and have worked with Coptic binding in one, two, four, six and twelve needles. I also make 'glitzy' earrings, from fabric, wire, glass beads and other materials. It is from these earrings that I created the name 'Glitz-Oh!'. The other art that has my equal passion and attention is what I call my 'garden art' - art in the sense of creating a soulful and spiritual retreat, through design of garden 'rooms', pathways, plant selection, and placement of objects (mine and those of other artists).

How did you get started making altered books?

I'm not completely sure of the *why* I chose books as my art expression, but a series of personal losses for me in 2001 (husband with cancer surgery, best friends moving away, then the World Trade Center tragedy - all within a 2-week time frame) are the *what* of my then-need to create some kind of art to express the pain I was feeling. Coming from a 'bookish' family (my mother is a retired librarian and admitted bibliophile, and we were all readers in our family), I think I just naturally went for a book to find solace. At the time, I had no idea altered books were becoming 'the thing' in the wider art community, but with my love of color, paper, and

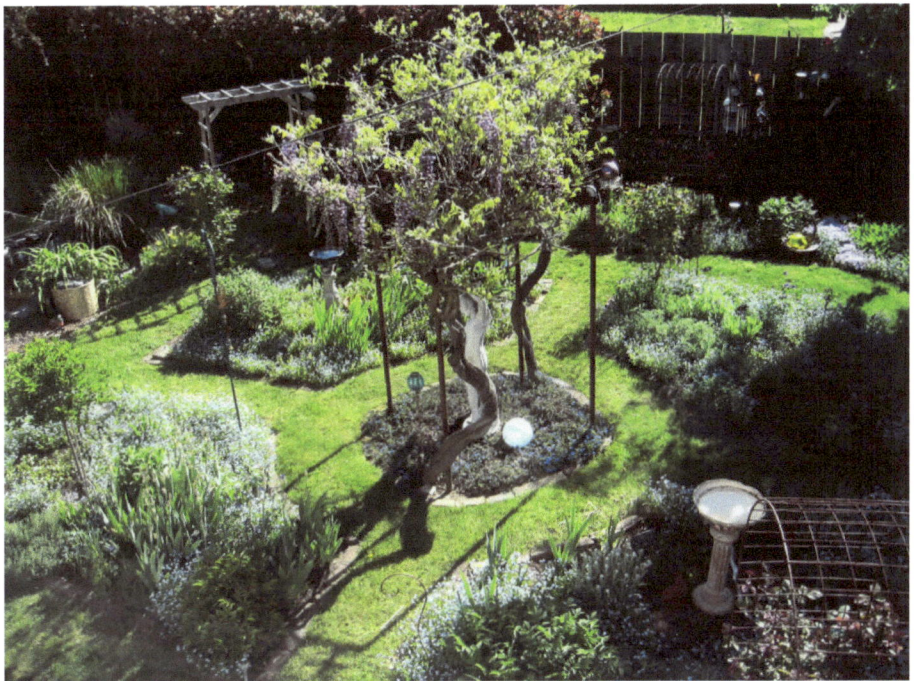

"Our central 'knot garden', as seen from my art studio window on the second story of our house. The knot garden is based on the Elizabethan era of formal garden design: beds arranged and fancifully bordered (usually with herbs or boxwood hedges) in various 'knot' patterns. Ours is the most basic, a Celtic Cross. I am of Celtic heritage. The bricks which border the beds of this central garden are from the old Medford Hotel, which was built in 1917 and burned down in 1987."

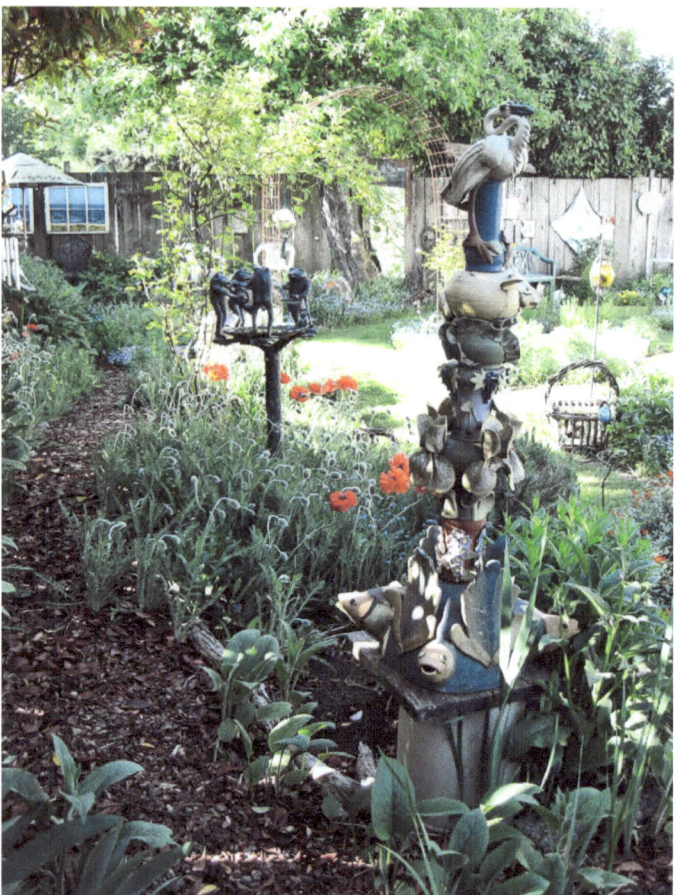

Above: "My artist friend Claire Barr Wilson created the 'finial' sculpture (each section is stacked one on the other, over a galvanized pipe and base). I purchased this for the garden, choosing each section that was representative of garden life I loved. Our frog musician birdbath is beyond the sculpture. The poppies are starting to bloom. On the south fence in the background is a remnant of an old quilt top, as well as an old mirrored door I found at a yard sale for $5.00. The door along the fence, under our ancient apple tree, is entry to the 'secret garden', which in reality is the reflection of my garden."

Right: "This is the 'Tea Corner' of the garden. The sun relection hides the words I painted on the umbrella - "Tea By the Sea". The old windows came from a neigbor's house when he put in new ones. Of course I just HAD to have them! I painted the seascape on them about 3 years ago, in acrylics. The mirror on the right reflects the circuit board and painting I did years ago on the back fence, titled 'The Circuitree of Life". The old kettle hanging on the left belonged to my husband's grandmother."

books, it seemed to me a natural medium with which to work.

Your books sort of go in a sculptural direction most of the time. How did that evolve?

To be honest, the expression of my feelings back in 2001 required a book (or books) that could actually represent the mood and emotion I was feeling; I felt a great need to have my art be three-dimensional in that expression. That is really how my book sculptures developed. Since I am not a clay sculptor, nor a welder, I devised my way of creating 3-dimensionally by carving, cutting, shaping , gluing and assembling books into representational objects. Though I have created many altered book pages and 'spreads', the dimensionality of the book structure interests me far more.

You mentioned that you teach classes occasionally. Is that something you'd like to do more of?

Yes, I do teach classes - in most of the art media I currently work with. I'm always delighted to be asked to teach, and I make the occasional overture to teach outside our local area. I really love sharing the art I make, and helping others to find their own art voice within whatever media we are working with. I had the good fortune to learn from others, and feel blesses to 'pass it forward', as the saying goes.

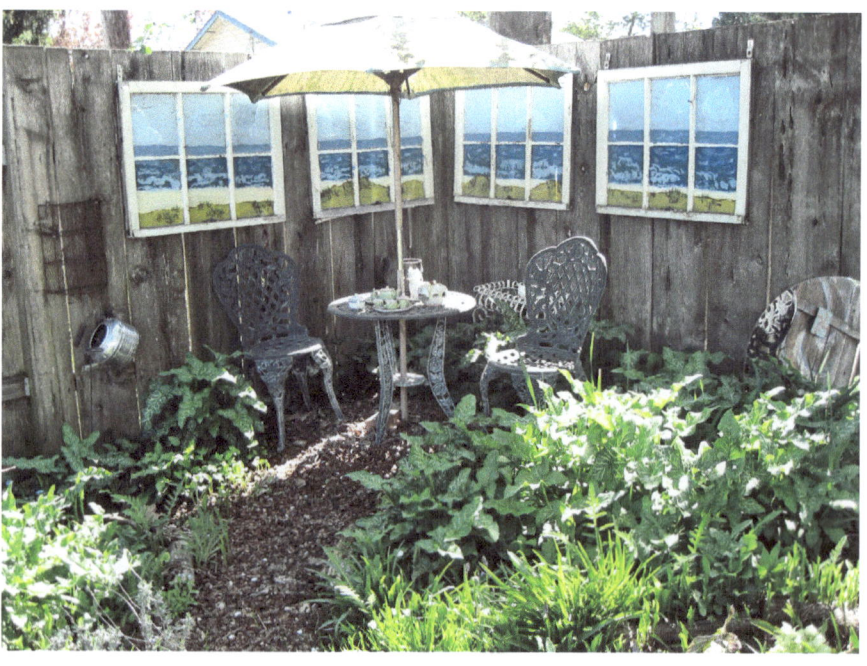

But that being said, creating my art is just as important, so I try to keep a good balance of my time. Because I have the luxury of not having to create art for my daily bread and butter (and yes, it is VERY much a luxury), I am well-versed in saying 'NO' to anything that does not feed my artistic soul.

You've also had some work in galleries. Are you heading in that direction with your work?

To some degree, yes. Much of my book art I have introduced through my website, blog, and internet group connections, but I have also approached local art galleries for the 'live' venue in which to participate. Galleries are a natural, both for visibility and 'credibility' for the artist. Because the area in which I live has fewer altered book artists who exhibit their work (as opposed to large metropolitan areas), and I hope because of my own expertise with book art, I have been blessed with positive gallery reception. I recently had the gallery owner of Gallery DeForest, in Ashland, Oregon come to tour my garden. During her visit, she viewed my book art as well, and she asked to have one of my book sculptures to exhibit next Fall in her gallery. I also have a few works currently on exhibit at the Rogue Gallery and Art Center here in Medford.

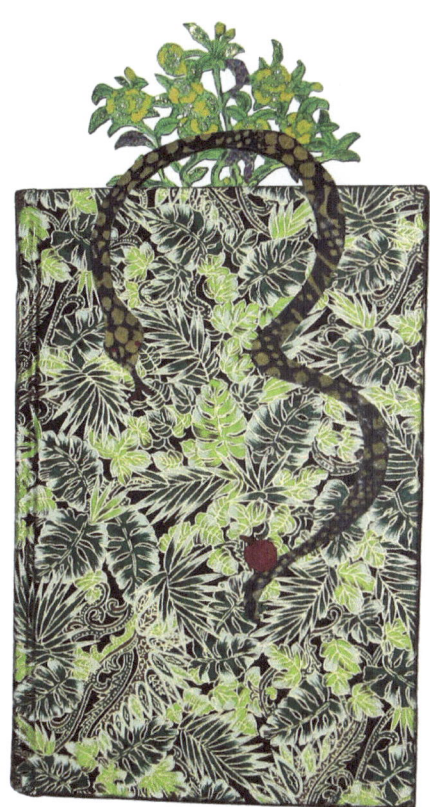 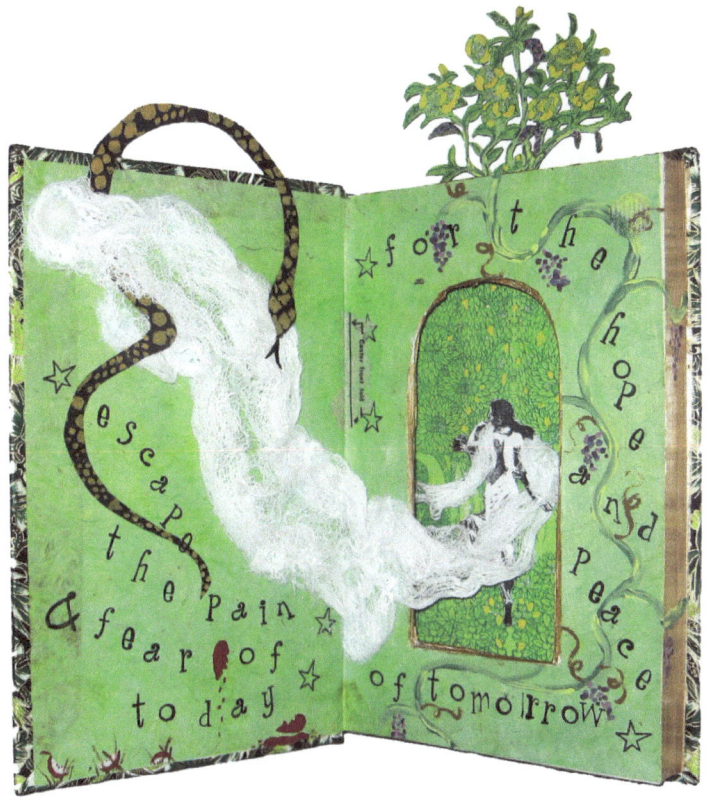

Above: I had this book in my head and just had to make it - so here it is. It is definitely inspired by my garden- but also by my feelings on the oppression of women in many cultures, and by my personal transitions in life in particular.

The book is based on a NEW Eden...one where women are not demonized- instead they find their voice, their peace, and their hope for a fulfilled life. They are not cast out, because the evil that is the serpent (man/society/self-imposed inferiority) is repudiated. That proverbial apple is cast away, and broken hearts are mended. The painted grapevines on the interior are patterned on the grapevine arbor of my garden deck, as well as the grapevines in our breezeway that I painted about 12 years ago. The cheesecloth drapery can be viewed in two ways - it is the woman's strong virgin spirit that she takes with her - OR - it is the cliche of woman that is cast off- to reveal the real strength inside....Take it either way...

Whether viewers see it or not, most of my book art reveals my thoughts about various aspects of life- whether humorous or serious. This book comes from my garden heart.

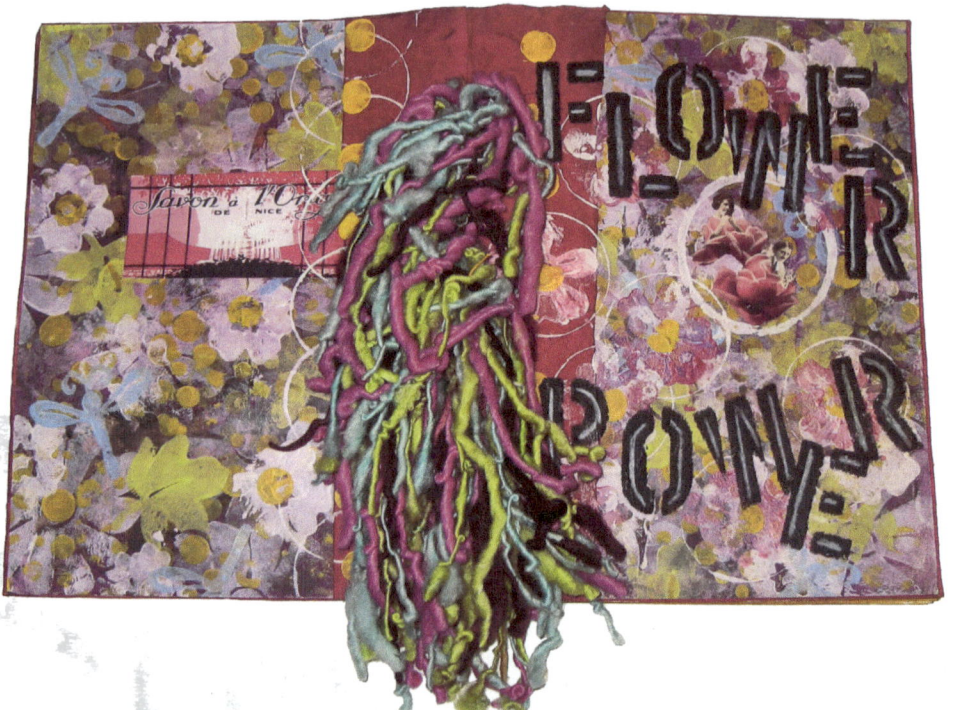

Left: Flower Power - Journal made from 11x17 cover stock.

"The cover was background paper I had made, and then embellished. Ten Two Studios images from the 'Pink' color collection are on the front and back covers. The colors in this journal are colors that occur in our garden - lavendar, purple creeping phlox, helianthemum, grapes, rudbeckia, a variety of green things....it's all there. The Flower Power title is symbolic for me - working in the garden empowers my spirit - it sets my mind free and is my inspiration for life. For me, the plants (all organic) are as alive and giving as any human - sometimes more so."

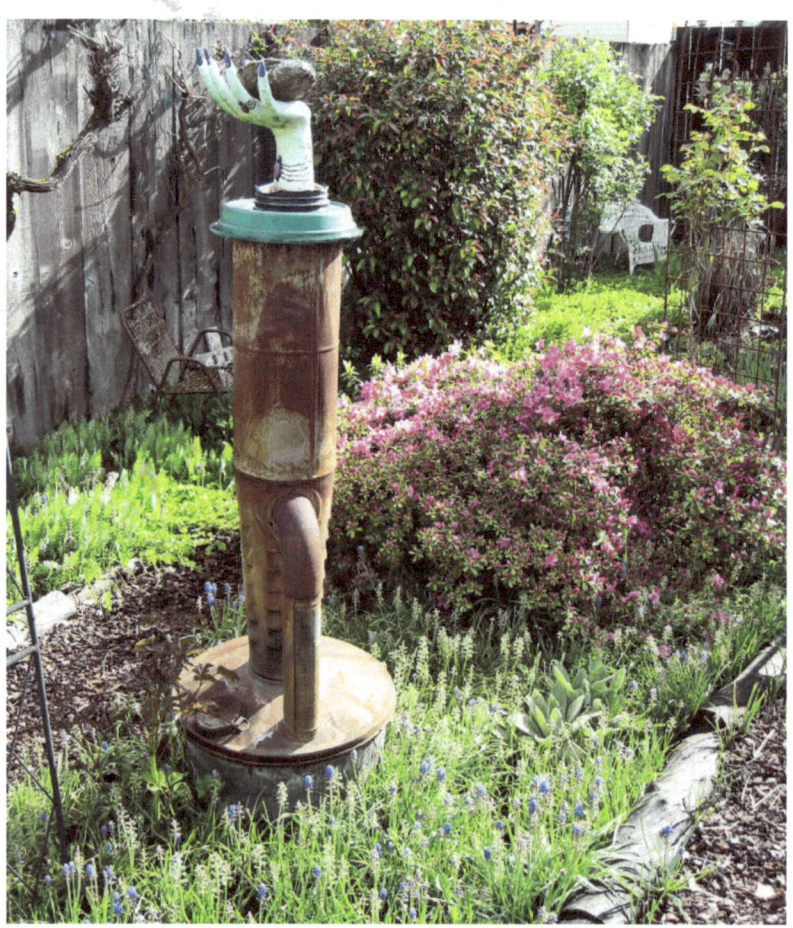

Left: "I love hands in all their infinite variety - I have a number of hands which emerge in various locations in the garden - this is a witch's hand, resting atop an old 'smudge pot' - which is an orchard heater - these items were used to keep the pears and other fruit crops from freezing, by heating fuel in them during crucial fruit production frost times. As cleaner and newer methods of orchard heating are now used (mostly windmills), these have fallen into disuse. We have a large fruit orchard industry in the Rogue Valley, but much less acreage than when we arrived 30 years ago. The azalea shrub to the right was in the yard when we moved in to our house - it is about 40 years old."

So, what are your creative goals?

One of my creative goals is to have my own book art exhibit in an art gallery. To that end, I am starting to create more to increase my body of work. Another creative goal is to have my art more widely published. I've been really fortunate to have had my art included in a variety of altered art publications so far (including Bad Influence!, thank you.), and plan to continue the submission process to various publications.

Where do you think your art will be in five years?

I really have no idea. My hope is that it will continue to flourish, develop and 'grow' with me, and that it will still be fresh and exciting , for me to create and for others to view. As I grow older, one thing I know for certain - nothing in life is certain.

OK, you know I've always been envious of the photos of your garden. How much property does it cover, and how much time do you spend working in it?

Our backyard is officially a National Wildlife Federation 'Backyard Wildlife Habitat'. The backyard space is 70 feet wide by 45 feet deep, which includes our 16 X 16-foot cedar deck. In addition to the garden/deck space, we have a 'breezeway' (also about 16 X16) which leads to the deck and garden. This is the 'official' entry point to our back yard. I call this my outdoor garden room - it has a vintage armoire, other furniture, paintings and prints, in addition to a detached storage 'shed' which is connected to our house by means of the entire roofline of the house. It is this connecting roof from our family room to the shed which protects the breezeway from the direct force of weather elements. There is a large wooden slatted divider which separates our 2-car carport and driveway in 'front', with the breezeway and garden in 'back'.

As to time spent in the garden 'working', I currently spend anywhere from no time in a day (except just enjoying) to perhaps a half-hour - mostly about ten minutes in the morning or evening pulling a few weeds here and there. In the early days of developing our yard into this garden space, I would spend hours before or after work, and on weekends, joyously pulling out and digging out grass and weeds, to create an aesthetically pleasing (and somewhat quirky) outdoor space.

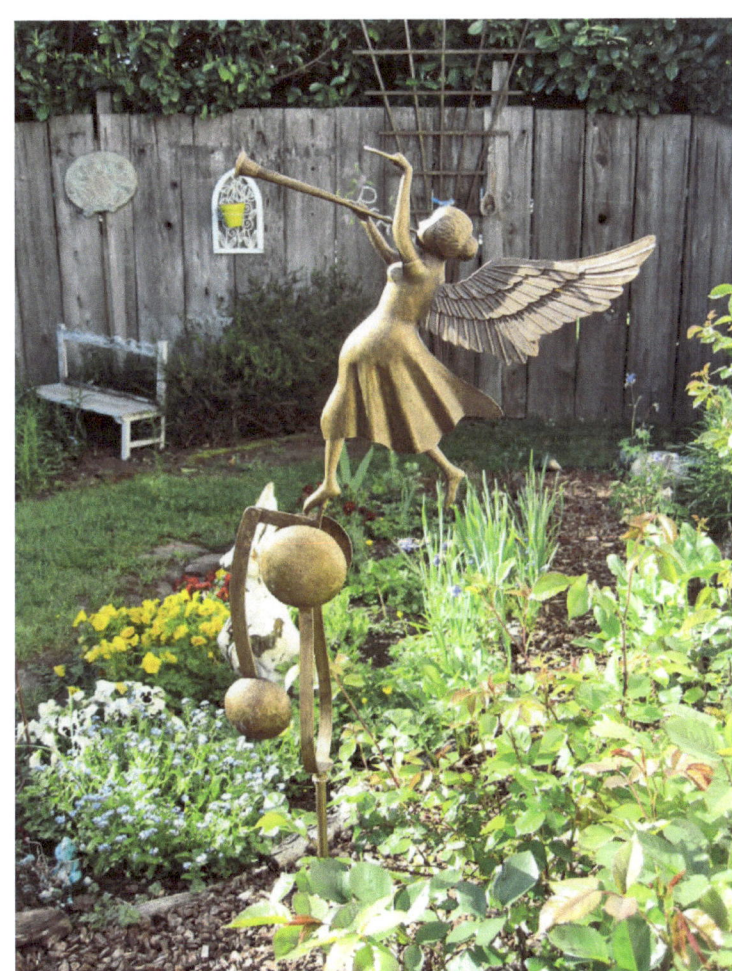

Above: "This is my 'Gardening Angel' - she is brass and rocks back and forth in the breeze. She heralds the dawn, facing East, and is nestled in a rose garden bed. At her feet is a large aging terra cotta-type rabbit - he's beginning to disintegrate. Just visible on the fence by the trellis is the word 'Peace', which I painted several years ago. A small bench, made by a local artisan from an old baby crib, is next to my 20+-year-old heather plant."

I've heard you describe yourself as a "garden artist". Is your garden part of your art? Does it incorporate pieces of your art?

My garden inspires my art either directly, or at the least, indirectly, through the solace and peace that it gives me. It provides me with refreshment when my art muse is absent or tired...and it also provides me with my love for color and texture, which directly carries over into my art. I collect art of other artists, and our garden has several ceramic sculptures by a very talented local artist, Claire Barr Wilson. We also have decorative birdbaths, gazing globes (witches balls- the mirrored glass balls in a variety of colors), wind chimes, metal archways, and more.

My own garden art consists of acrylic painting in the breezeway, on furniture, storage door, carport divider and breezeway gate. I also have a computer circuit board and abstract painting I created years ago on part of our back fence, in addition to old house windows which I painted with a seascape, in the 'tea corner'. The seascape reminds me of the ocean, my dream home away from home. Because my book art is not 'weather-tolerant', I have my book art indoors, on walls, shelves, tables, etc.

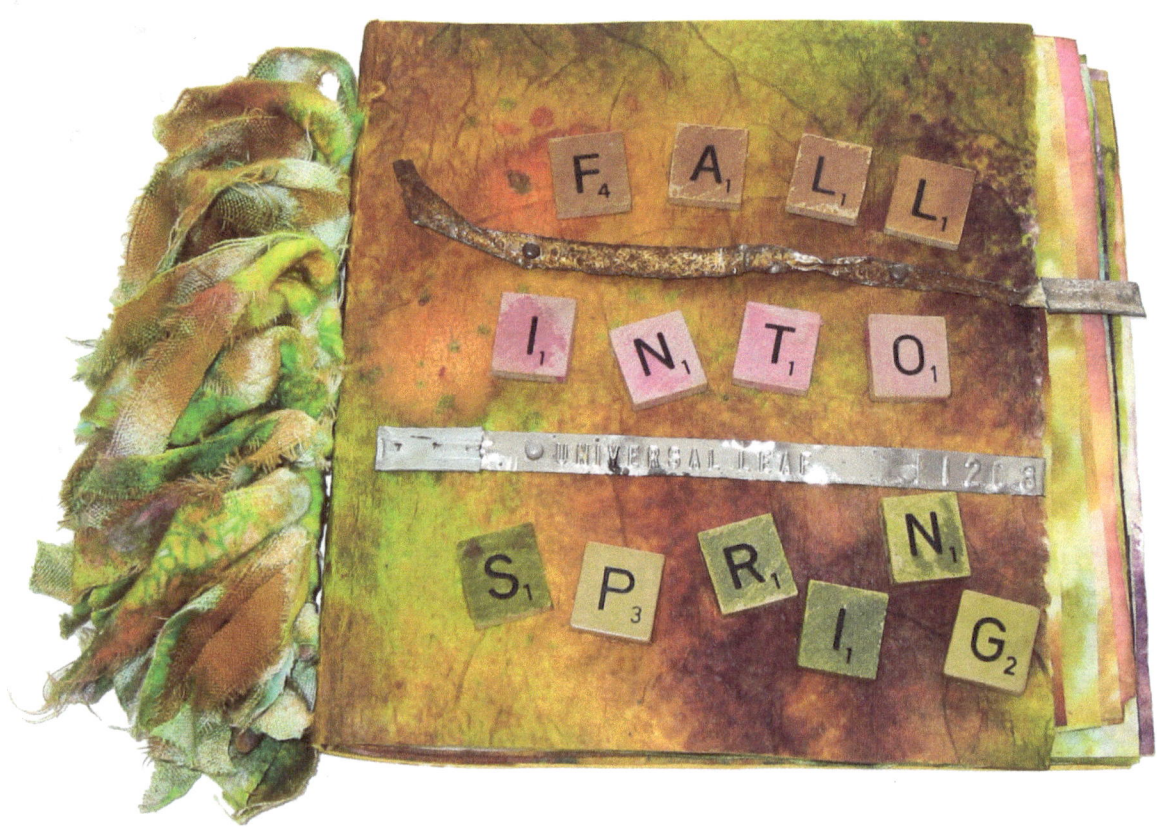

Above: Fall Into Spring - Journal made from 11x17 cover stock and recycled materials.

"It is made entirely from my 'cast off' or recycled 'art materials'- paint-soaked baby wipes, paper towels, one sheet of 11X17 cover stock, flannel remnants. Each page has a stamped saying referring to nature or gardens or spirituality. I usually have dual meanings in my artwork - especially my book art. This one represents how the garden dies back in the Fall, only to re-emerge strong and vibrant in the Spring. It is a metaphor for my thoughts on spiritual life as I feel it. (not to be confused with my thoughts on religion!!) The rusted metal on the cover was a gift from fellow Altered Book Group member Christy Grant. The rusted piece is Fall- the 'clean' piece is Spring. The game letters are 'just because' I love to play Scrabble!"

How does the time you spend in the garden influence your time in the studio?

The time spent to just 'be in the moment' in the garden, or to put my hands in the dirt, or to paint quirky things around the area, is what keeps my spirits high, and my emotional and artistic energy inspired. I sit on various benches or chairs, depending upon the time of day and the season, to read, sip tea, watch the fish in the pond, or just think about life in general. I developed the tea corner for little 'tea parties' with friends and our grand daughters. Everything that feeds my spirit in the outdoors also contributes to my artistic spirit in the studio.

Thanks for letting us into your world, C.

For more work by Corinne Stubson, visit her web site, Glitz-Oh.com.

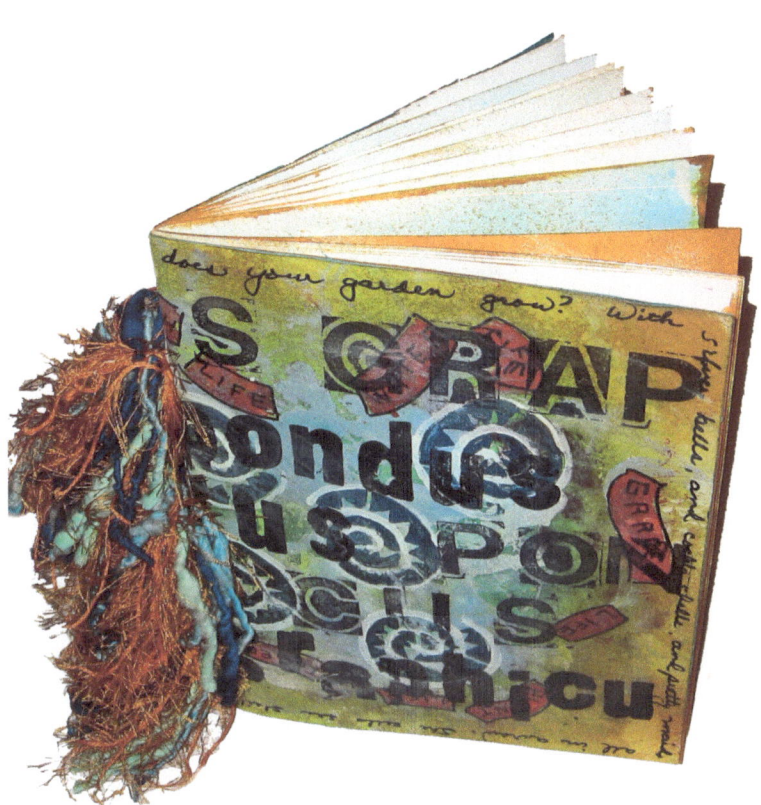

Above: Garden Burst - 11x17 mixed media collage on cover stock.

"This collage is one of my 'background' papers, but I'm leaning towards using it for a garden journal cover instead. The design and colors are inspired by several elements of my Spirit Garden - namely seasonal color, occasional chaos of random weeds, and the focus of water - as both home to our koi and goldfish, but also as a sound element of the garden. The crinkling of the collage surface is the rippling sound of the water as it splashes from several outlets - a koi fountain, a mini waterfall, and a filter outlet. The black ink and gold spray webbing both signify the reflective pattern sunlight makes on the surface of the pond, which is never still."

Left: Pondus Graphicus - 11x17 garden journal made from cover stock.

"The cover started out as background paper...and developed from there. It was inspired by our garden pond, and my love of graphics, alphabets, color and pattern. The binding is a simple pamphlet binding. The fibers on the spine are handspun and hand dyed wool from Tracie Lampe, with some orange fun fiber added in. I have no idea why my mind works as it does, but the Latin sounding title seemed to fit. The garden is a continual source of inspiration for me. The orange fibers remind me of our koi."

BAD INFLUENCE - MYSTERIES OF THE GARDEN - JUNE 2007

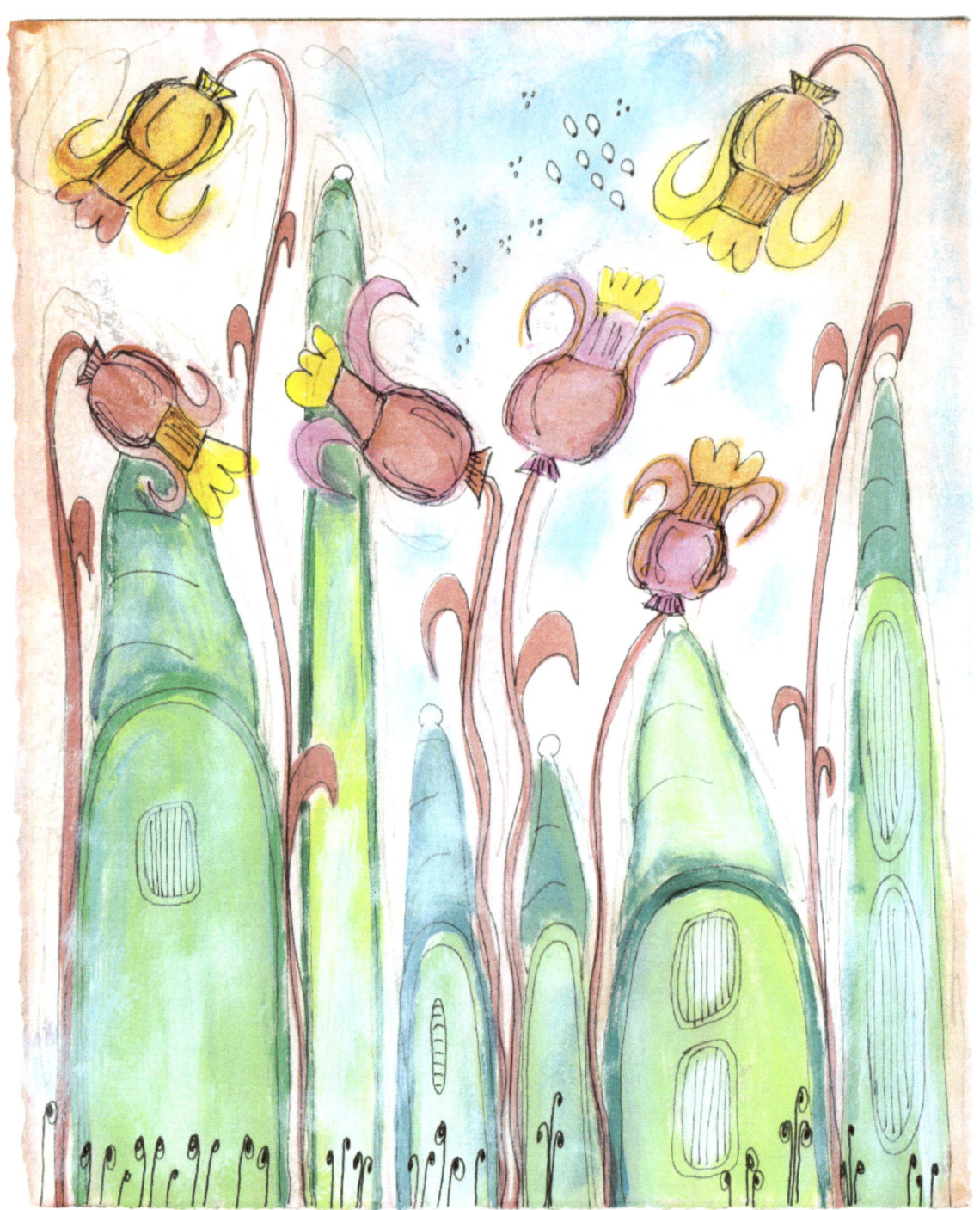

Garden in the Hood
Acrylics, Pitt pens and gelly glaze pens
on 8 x 10 inch hot press watercolor paper.

I use neighborhoods as a common theme in a lot of my work. I incorporated a whimsical flower garden for this fantasy neighborhood.

Art By
Tara Ross

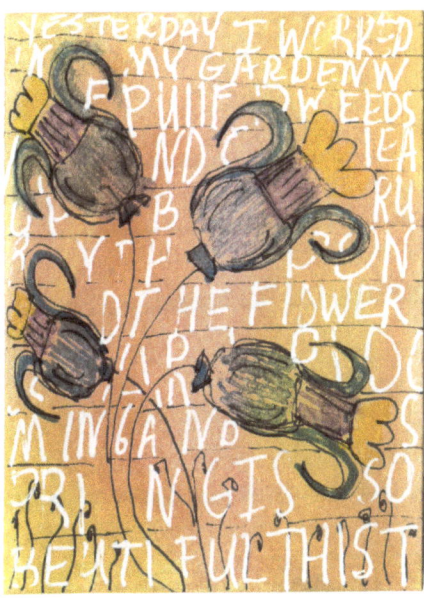

Mysteries of the Garden
Acrylics, Pitt pens, and UniBall pens.

I journaled my thoughts about yesterday's garden chores. We worked in the garden all day, planting, weeding and cleaning up for spring. It was a beautiful day.

Three Flower Girls
Acrylics, Pitt pens, and gelly glaze pens. 4 x 6 inches.

I collaged images of vintage photos in the piece. The flowers are my own design.

not just another bland, boring how-to thing...

Visit online at
TenTwoStudios.com
or email at
TenTwoStudios@yahoo.com

The Magic of Monet's Garden

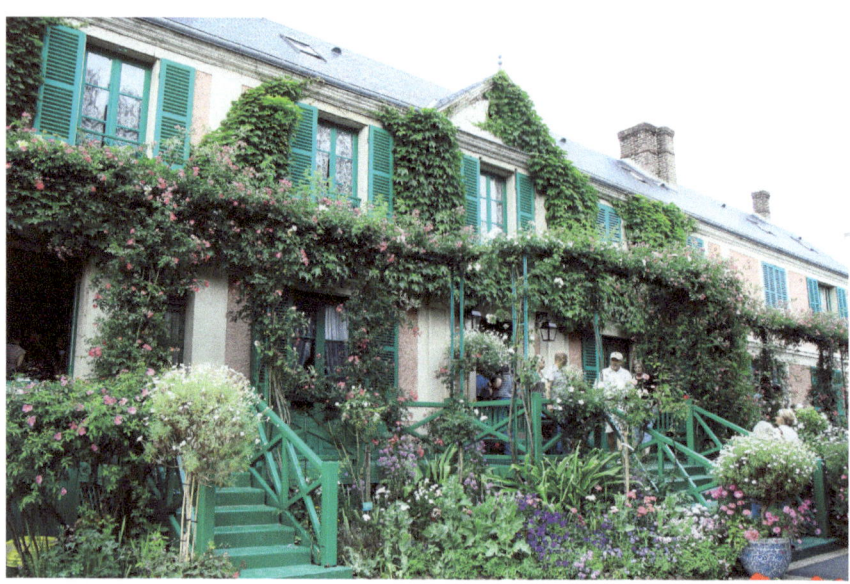

Photo courtesy of Spedona and Wikimedia Commons, under the GNU Free Documenation License.

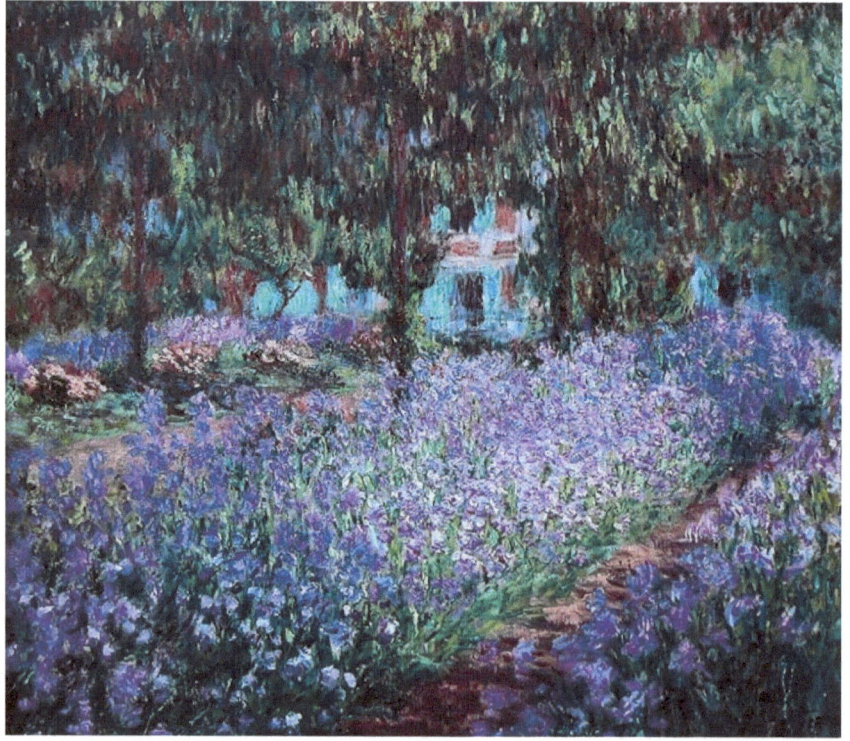

Monet's Garden at Giverny, 1900.

A couple months back, I watched The Impressionists, the BBC mini-series about the friendship between painters Claude Monet, Auguste Renoir, Edgar Degas, Paul Cézanne and Édouard Manet, as told by Monet in his old age.

Like many of you---and I know it really is many of you, because I read it in daily emails---I have a hard time wrapping my head around the idea that artists are real people. Especially artists like these guys, whose work hangs in museums and is studied in school. This miniseries really brought home the idea that in their time, they were just a bunch of guys who hung out at a local bar, couldn't pay their rent on time, and generally made people mad with their art. Gee, that sounds like a whole bunch of people I know...

One of the really wonderful aspects of the miniseries was the amount of time spent showing the artists painting. Now, I always knew that Monet was famous for painting *en plein air*, which is a fancy French way of saying he dragged his art supplies all over the great outdoors, and set up his easel in crazy places like train stations and hay fields. He also spent a whole lot of time painting his own garden in Giverny---a garden that still exists today, and is much photographed by visitors.

Monet rented the house in Giverny in 1883. By 1890, he had earned enough from his work to purchase the house, and began digging the famous water lily pond. The pond became a focal point as he began to work in series, painting multiple

views of the same elements. He would often paint a dozen or more paintings of the same location, such as the Japanese bridge that arches over the pond---a bridge that still stands today. He also did a series of twelve very large canvases of water lilies between 1916 and 1926. These paintings were given to France, and displayed together in a space designed for them at the Orangerie in Paris.

Monet lived in the Giverny house for 43 years, until his death in 1926. He left behind him a wonderful chronicle of the growth and seasonal variations of his fabulous garden. He also left letters and journals that expressed his desire to capture the mysteries of that garden:

"I have set up my easel in front of this body of water that adds a pleasant freshness to my garden ; its circumference is less than 200 metres and its image aroused in your mind the idea of infinity."

"I want to paint the air in which the bridge, the house and the boat lie. The beauty of the air in which they are, and that is nothing other than im-

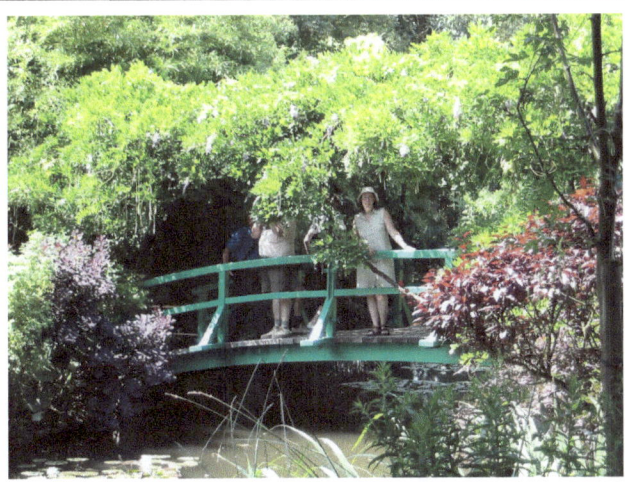

Photo courtesy of Donar Reiskoffer and Wikimedia Commons, under the GNU Free Documenation License.

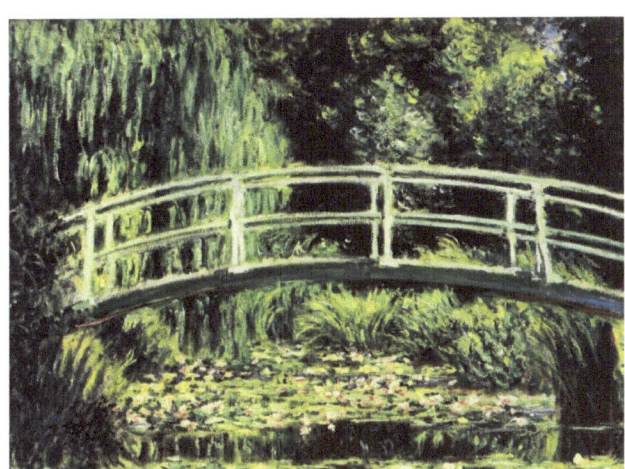

Les Nympheas Blanc, 1899.

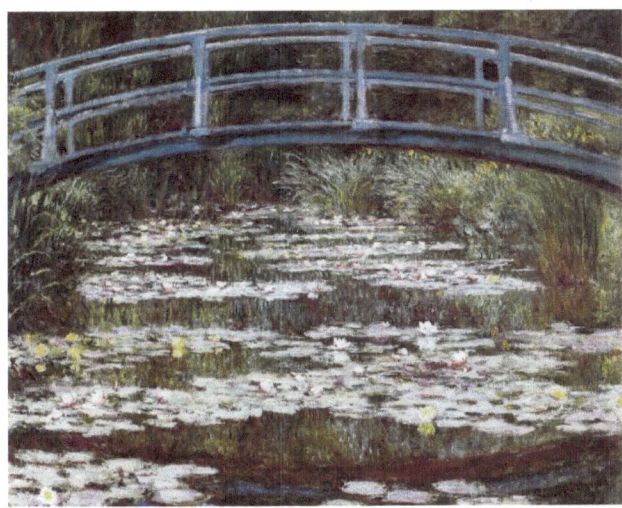

Water-Lily Pond, 1899.

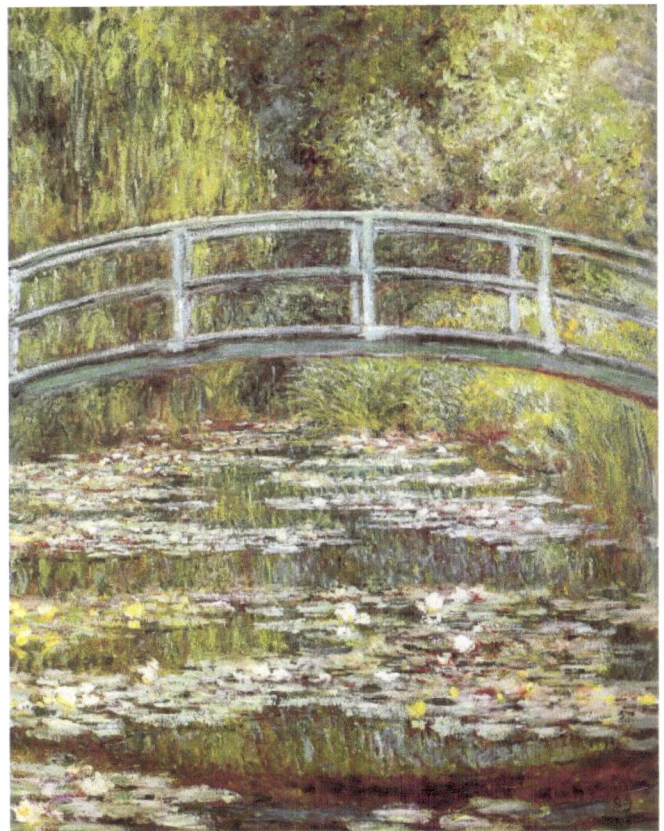

Water-Lily Pond, 1899.

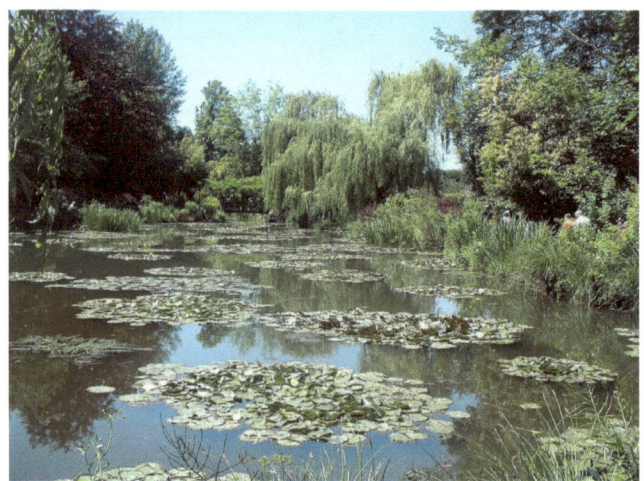
Photo courtesy of Pierre-Étienne Nataf and Wikimedia Commons, under the GNU Free Documenation License.

possible."

"Everything I have earned has gone into these gardens." (I particularly liked this one, since I'm in the middle of landscaping my yard right now...)

"The passing cloud, the cooling breeze, the sudden storm that threatens to burst and finally does, the wind that stirs and suddenly blows with full force, the light that fades and is reborn are all things, elusive to the eyes of the uninitiated, that transfigure the color and shape of the bodies of water."

"I'm good for nothing except painting and gardening."

I spent a few minutes online before I sat down to write this, searching for photos that matched familiar Monet paintings. Naturally, I can't show most of those photos here---so, when you're done reading, jump online and do a search on Google Images for "monet giverny", and you'll see a bazillion lovely photos mixed in with his paintings.

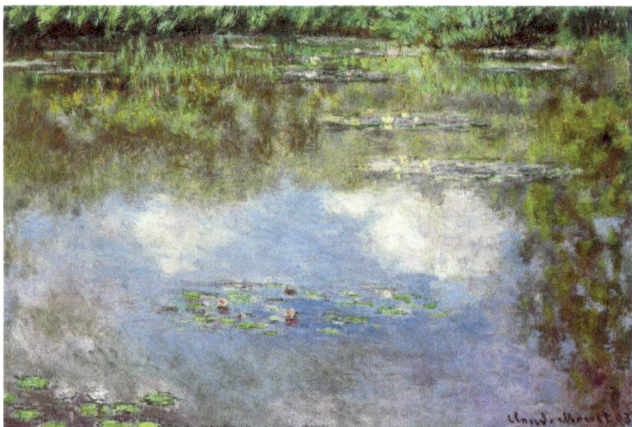
Water Lilies (The Clouds), 1903

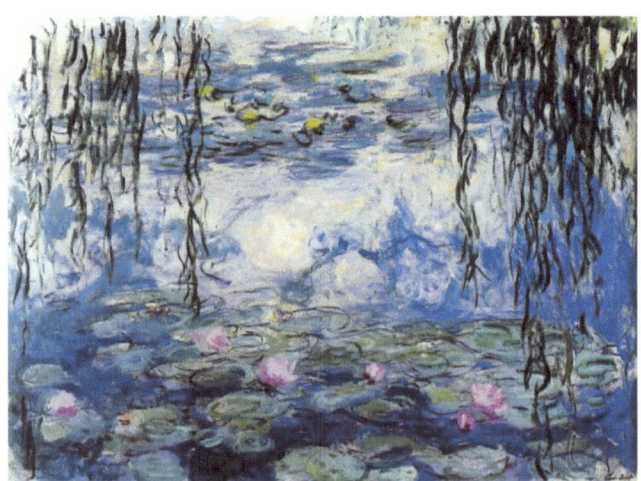
Water-Lilies, 1916.

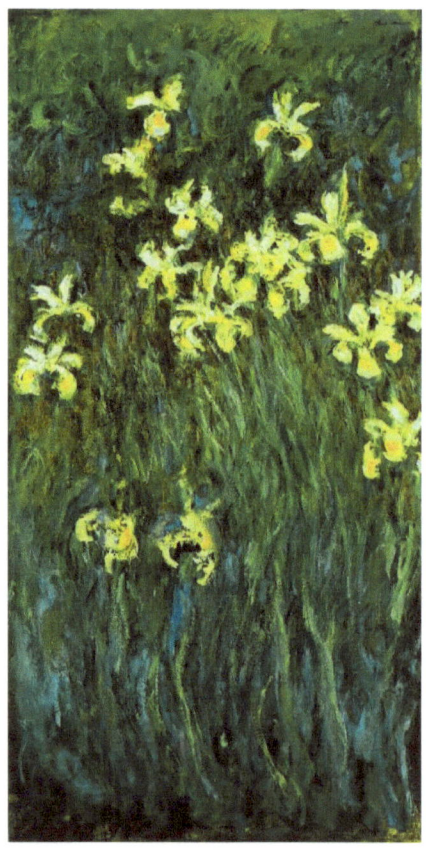
Yellow Irises, 1914.

Art By
Roberta Schmidt

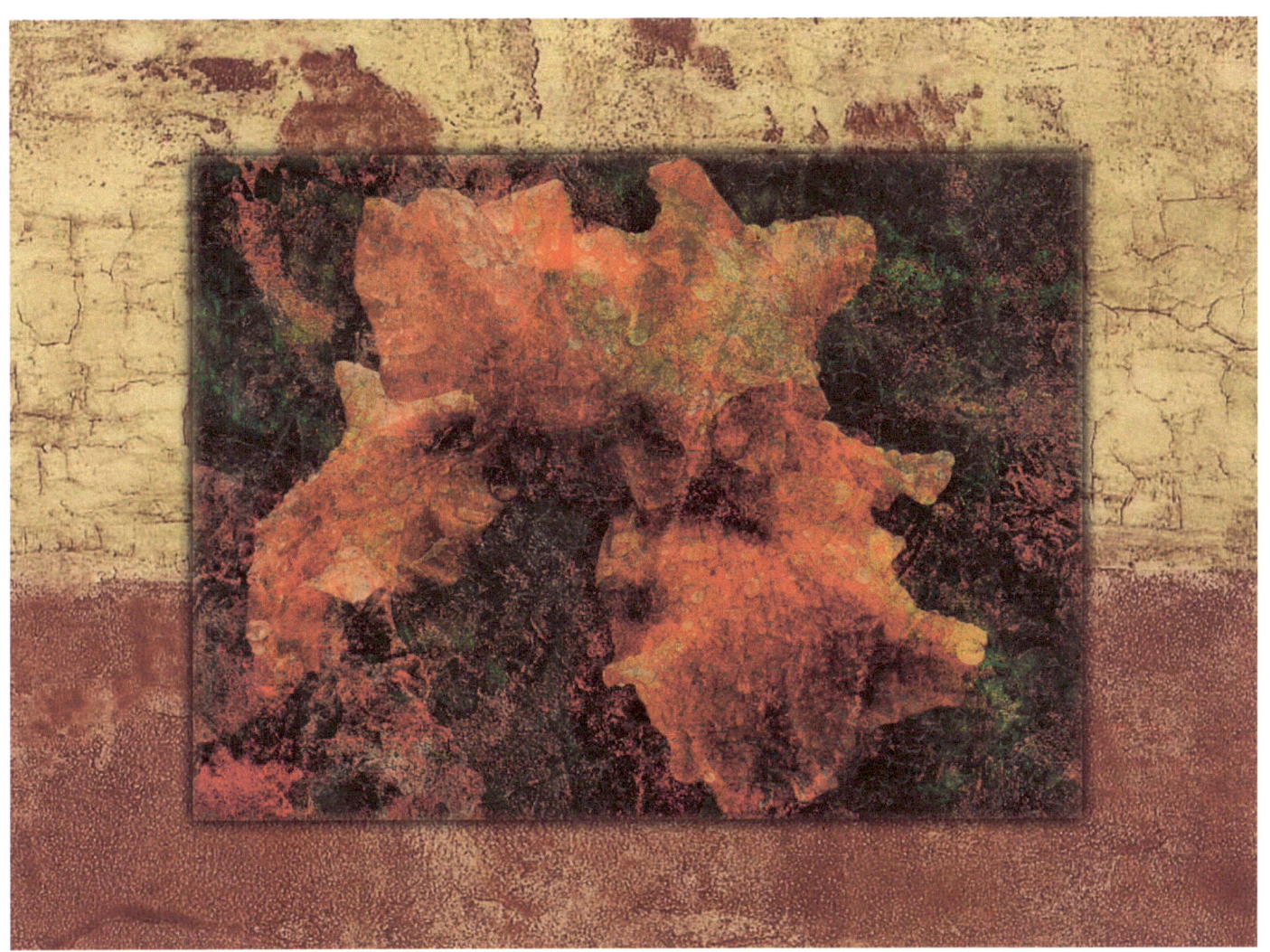

Altered Iris
Digitally altered photo.

I took this photo earlier this month, after a nice spring rain. I used a Konica Minolta digital camera, and ACDsee software that came with my husband's digital camera, to play around with layering on other digital images, adding saturation, and texture. The original color of the iris is a deep purple, but I like the look of an old and weathered painting that I ended up with. That is the fun with digital art, when you start out with a project, you never quite know how it will end up!

Art By
Hanna Andersson

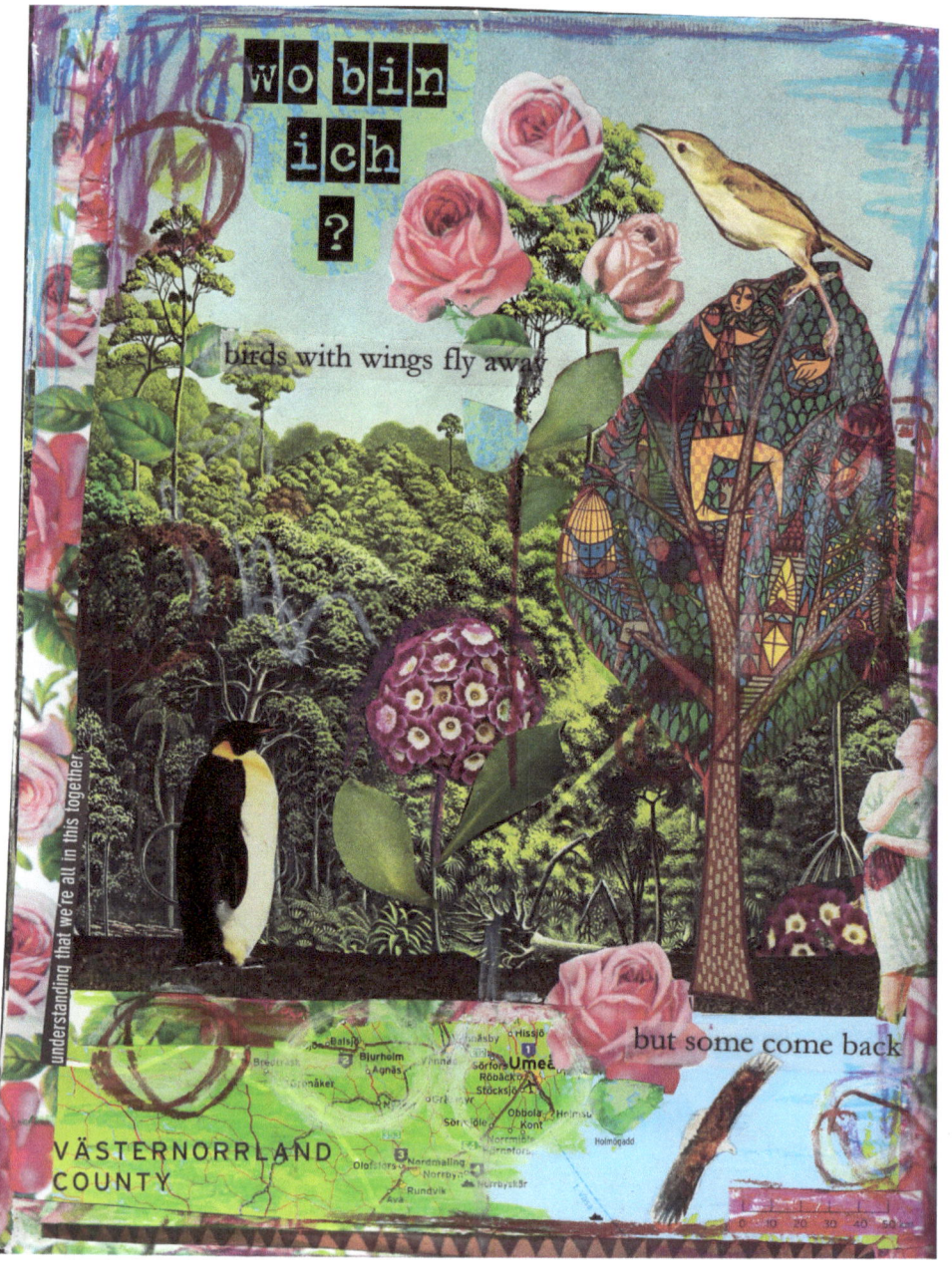

Finding My Own Garden
Collaged art journal page.

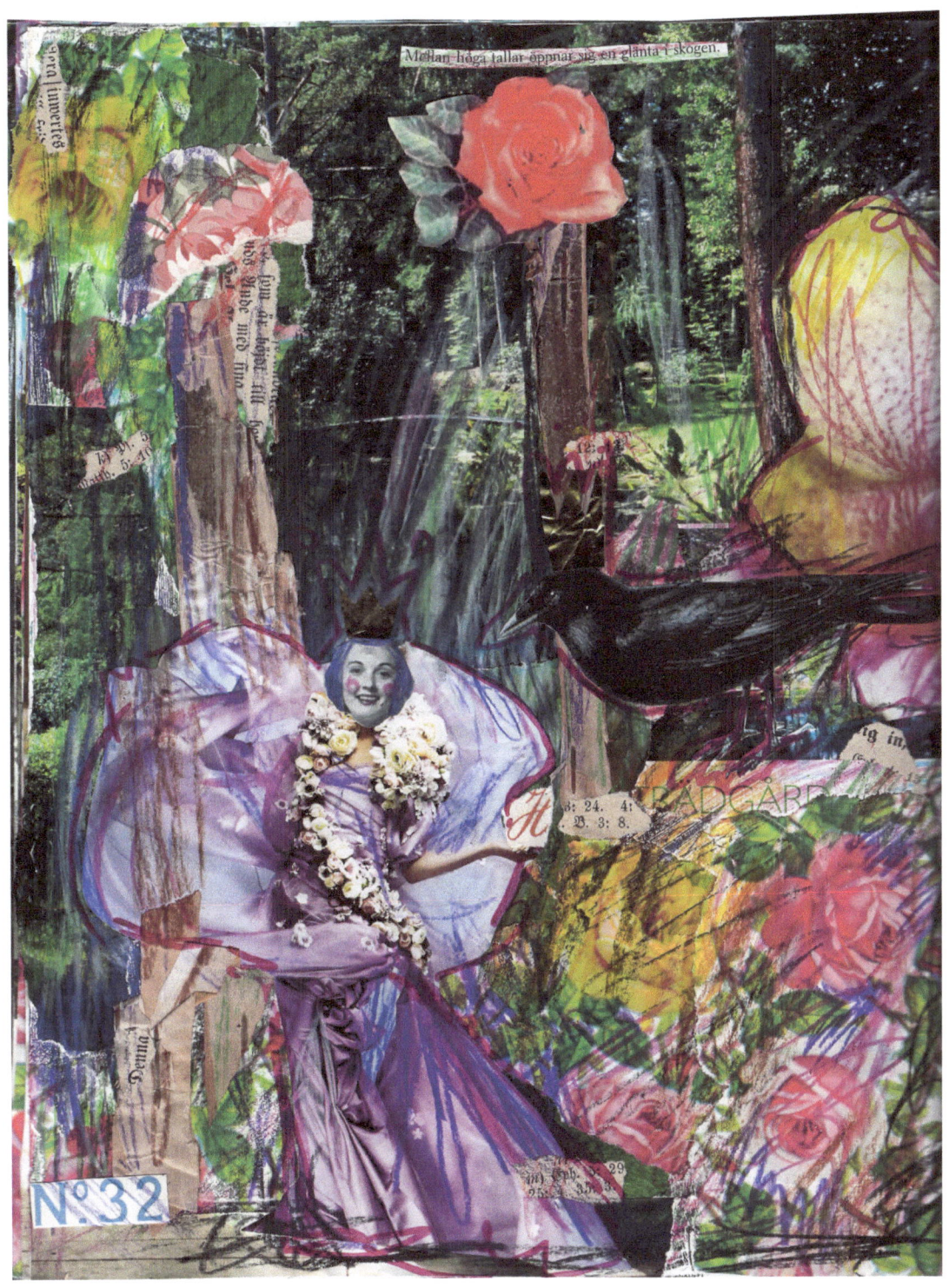

My Happy Sorrow Garden
Collaged art journal page.

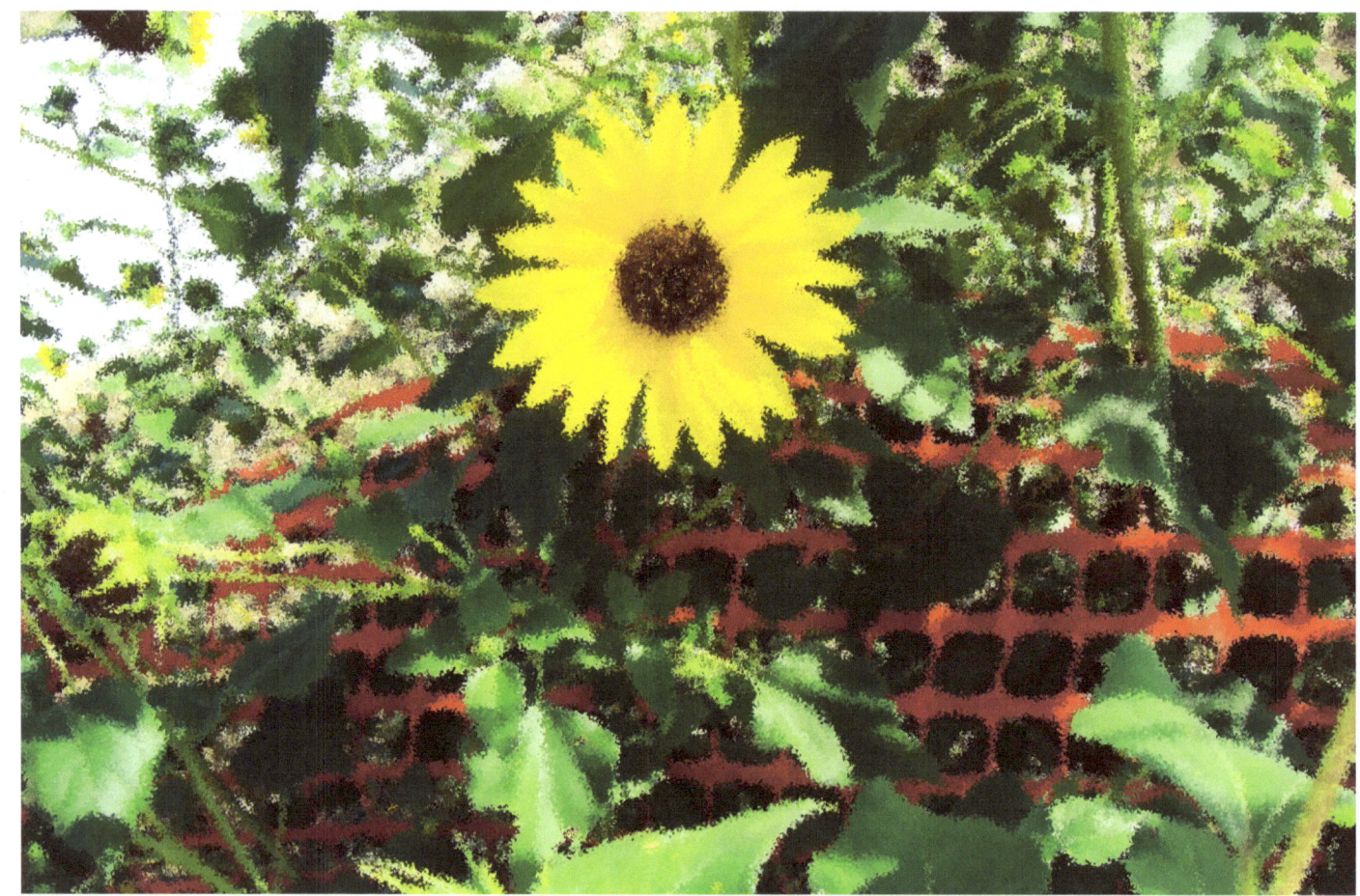

Sunflower in Construction Zone
Digitally altered photo.

While my friend Robin was photographing a large construction site as an example of urban blight, I was busy snapping pics of the plants that had been springing up amongst the supplies. Even though the area had been stripped of all things green prior to the start of construction, Nature always wins in the end. Most of the ugly new tract homes already had these wild sunflowers growing in their backyards, whether the developer wanted them or not.

Notices & Disclaimers

Bad Influence is a printed zine produced by Lisa Vollrath of Ten Two Studios. The articles and images presented here are for your entertainment only.

Photos on pages 4-5, © 2007 by Deirdre Abbotts. Photo on page 6, © 2007 by Cyndali. Photo on page 7, © 2007 by Debe Friedhoff. Photos on pages 8-15, © 2007 by Corinne Stubson. Photos on pages 16-17, © 2007 by Tara Ross. Photos on pages 18-20 are courtesy of Wikimedia Commons. Photo on page 21, © 2007 by Roberta Schmidt. Photos on pages 22-23, © 2007 by Hanna Andersson. All other contents copyright © 2007 by Lisa Vollrath and Ten Two Studios. All rights reserved worldwide.

This publication is protected under the US Copyright Act of 1976 and all other applicable international, federal, state and local laws, and all rights are reserved.

Any trademarks, service marks, product names or named features are assumed to be the property of their respective owners, and are used only for reference. There is no implied endorsement if we use one of these terms.